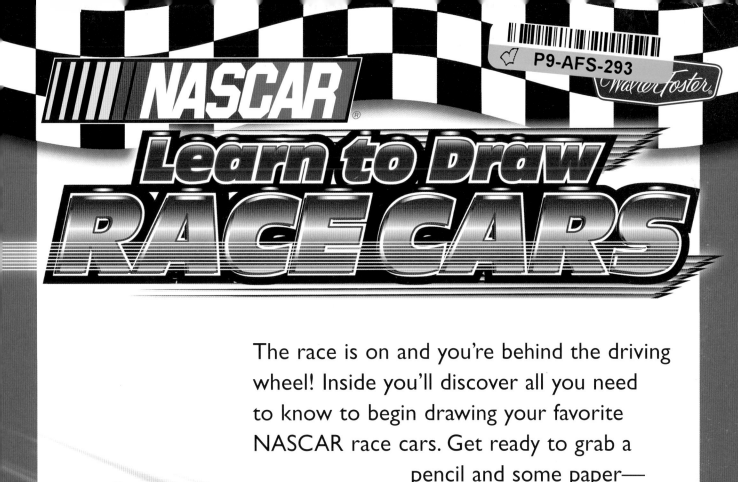

# NASCAR

## Learn to Draw RACE CARS

*Walter Foster*

The race is on and you're behind the driving wheel! Inside you'll discover all you need to know to begin drawing your favorite NASCAR race cars. Get ready to grab a pencil and some paper— and start your engines!

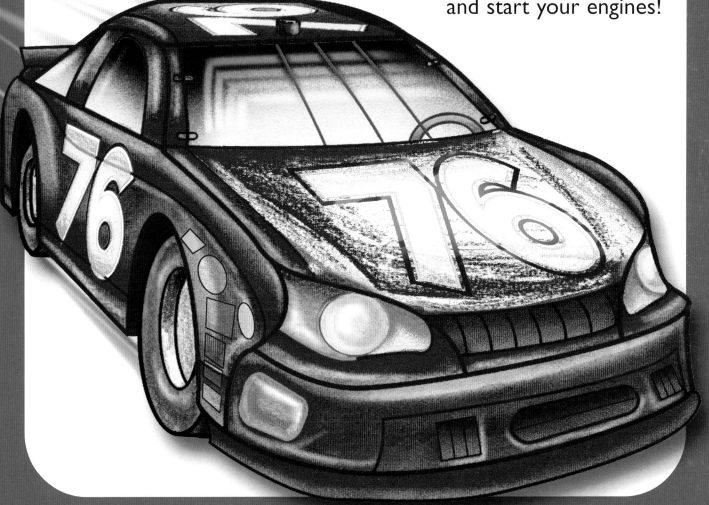

NASCAR stands for the National Association of Stock Car Auto Racing.

NASCAR was officially formed in 1948 and currently sanctions three national racing series: the NASCAR NEXTEL Cup Series, the NASCAR Busch Series, and the NASCAR Craftsman Truck Series. Races are held throughout the year and all over the nation. Races stretch from California to Florida and are held on a variety of race tracks and courses. Millions of fans watch NASCAR events on television and at the race track each year. NASCAR has grown into one of the nation's most popular spectator sports.

## NASCAR Race Cars

Early race cars were initially raced in what was then called the "Strictly Stock Division" because they closely resembled the everyday (or standard) model vehicles of the time. Few modifications, aside from engine tuning, were made or required of these cars.

**1950s Race Car**

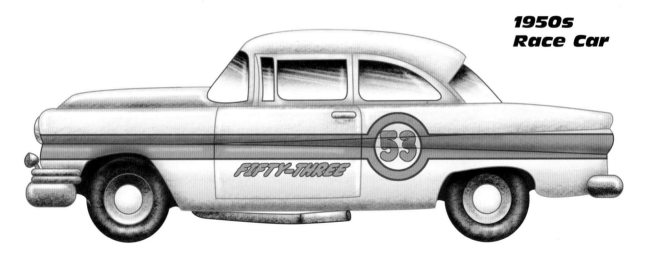

Like the early model race cars, the bodies of today's NASCAR race cars are based on everyday vehicles that are manufactured by companies like Chevrolet, Ford, Dodge, and Toyota. But the body style is the only thing that these stock cars and their standard model counterparts have in common. NASCAR race cars have very powerful engines, most producing more than 700 horsepower, which is more than three times the average horsepower of a regular passenger car.

**Standard
Passenger
Car**

**Modified
Race Car**

## What Are NASCAR Craftsman Trucks?

NASCAR Craftsman trucks are based on standard half-ton, short-bed truck models. Unlike standard trucks, they do not have a functional bed, so they aren't equipped to haul cargo. In fact, NASCAR Craftsman trucks are used only for racing purposes—they actually have more in common with race cars than they do with regular trucks—producing an average of 750 horsepower during a race.

Standard Truck

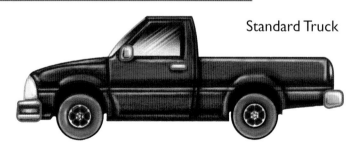

NASCAR Craftsman Truck

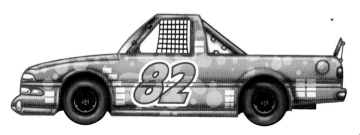

# Parts of a Race Car

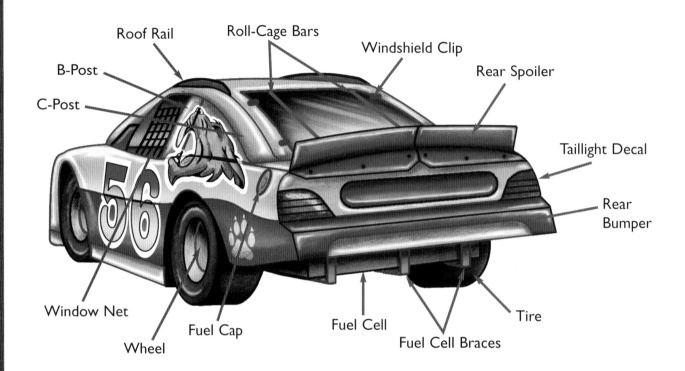

Roof Rail

Roll-Cage Bars

Windshield Clip

Rear Spoiler

B-Post

C-Post

Taillight Decal

Rear Bumper

Window Net

Fuel Cap

Wheel

Fuel Cell

Fuel Cell Braces

Tire

# What Does Each Flag Mean?

The different colored flags in NASCAR each have their own specific meaning to the drivers on the race course. These visual signals ensure that all drivers receive the same information, whether it's to slow down for an accident ahead or speed up to resume a race that was interrupted. These flags are typically flown from the starting/finish line tower.

The green flag is used to begin the race. It also signals drivers to resume after a race has been interrupted.

The yellow flag signals caution and is usually flown after an accident or in the case of debris on the track. The race cars will all slow down upon seeing this flag.

The blue flag with a yellow stripe tells drivers to move to the side for a faster car that is coming from behind (typically the leader of the race).

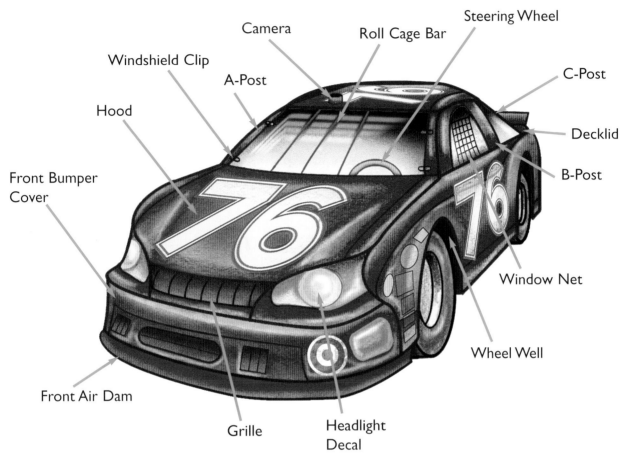

Camera

Windshield Clip

Roll Cage Bar

Steering Wheel

A-Post

C-Post

Hood

Decklid

B-Post

Front Bumper
Cover

Window Net

Wheel Well

Front Air Dam

Grille

Headlight
Decal

The black flag means that there is a problem with a particular race car— this car must enter the pit area immediately. Usually this flag is displayed when a driver has violated the rules or if there is a mechanical problem.

The red flag is displayed when the race must completely stop. There may be a serious problem or condition in which a yellow flag cannot be used. All drivers must park their cars if this flag is displayed.

The white flag tells the lead driver that only one lap remains in the race.

The checkered flag is used to signify the end of the race. The first car to pass the checkered flag wins the race.

# Tools & Materials

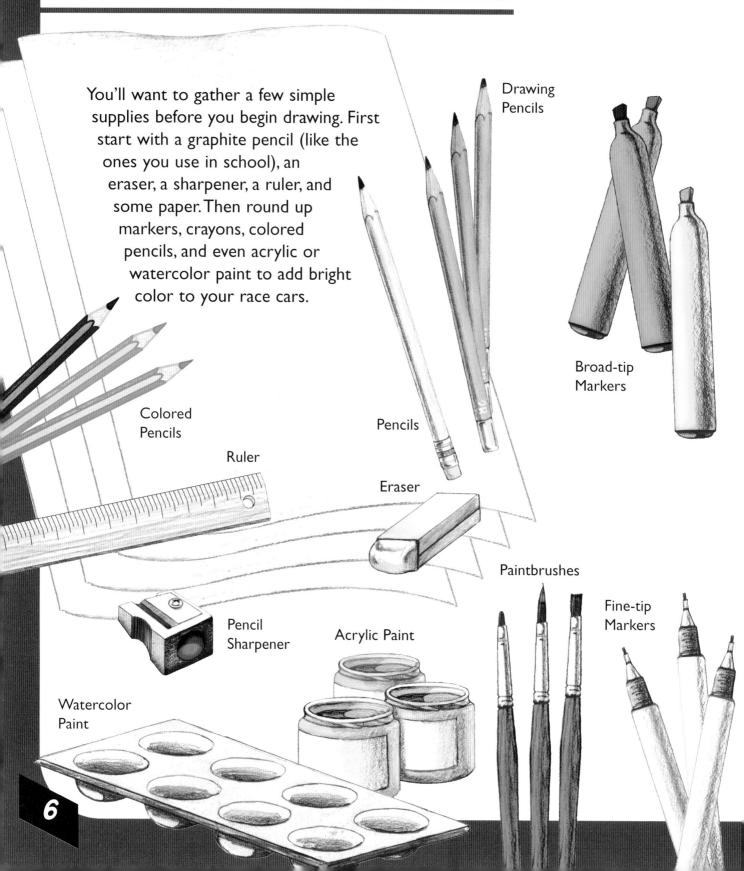

You'll want to gather a few simple supplies before you begin drawing. First start with a graphite pencil (like the ones you use in school), an eraser, a sharpener, a ruler, and some paper. Then round up markers, crayons, colored pencils, and even acrylic or watercolor paint to add bright color to your race cars.

Drawing Pencils

Broad-tip Markers

Colored Pencils

Ruler

Pencils

Eraser

Paintbrushes

Fine-tip Markers

Pencil Sharpener

Acrylic Paint

Watercolor Paint

# How to Use This Book

 Start your drawings by blocking in guidelines for the basic shapes.

 Each new step appears in blue, so you'll always know what to draw next.

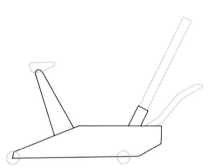

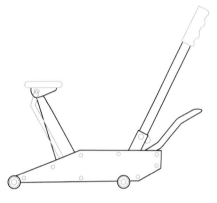

 Simply follow the blue lines to add each new feature.

Refine the lines of your drawing and add details.

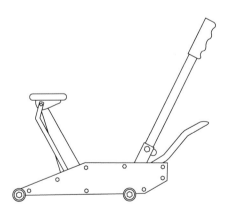

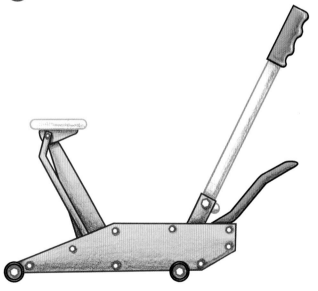

 Darken the lines you want to keep and erase the rest.

 Use colored pencils, markers, crayons, or paint to add a splash of color.

To draw NASCAR race cars, it's important to know a little bit about the rules of perspective. These "rules" will help you draw cars that appear to have depth and dimension. Getting the perspective just right can be kind of tricky, but plenty of practice will have you drawing realistic race cars like a pro in no time!

# One-Point Perspective

To draw a box in one-point perspective, first draw a rectangle. Then draw a horizontal line, called the "horizon line" (HL), above, below, or through the center of the rectangle. (The position of the HL will determine whether you see the box from the front, from below, or from above.) Then draw a dot, called the "vanishing point" (VP), on the HL, at the center of the rectangle. Receding lines (in this case, the sides of the box) that are parallel in real life will meet at this VP.

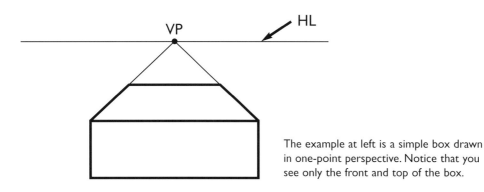

The example at left is a simple box drawn in one-point perspective. Notice that you see only the front and top of the box.

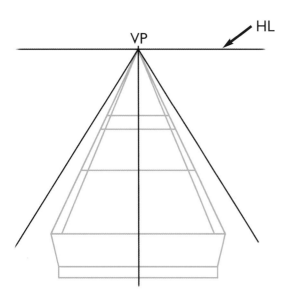

 Here the same rules have been used to draw a longer box in one-point perspective. The horizontal lines on the box mark the front of the car, the windshield, and the roof.

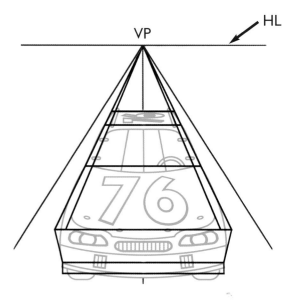

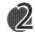 Once the box is drawn in perspective, you can draw the car inside of it. The box will help you draw the car in the proper perspective. Here we have a top front view of a NASCAR race car.

# *Two-Point Perspective*

To draw a box in two-point perspective, first draw a vertical line to mark the corner of the box that will be closest to you. Next draw the horizon line (HL) above, below, or through the center of the rectangle. Then draw a vanishing point (VP) at each end of the HL. Receding lines (in this case, the sides of the box) that are parallel in real life will meet at one of the VPs.

This is a simple box drawn in two-point perspective. Notice that you see two sides of the box, as well as the top.

Start with this line.

**1** Here the same rules have been used to draw a longer box in two-point perspective. In this example, the lines that recede toward the vanishing point on the left mark the sides of the car; the lines that recede toward the right mark the front and back of the car, the windshield, and the roof.

**2** Once the box is drawn in perspective, you can draw the car inside of it. The box will help you draw the car in the proper perspective. Here we have a three-quarter view.

NASCAR race cars come in all colors—from pink to black. And each race car has unique graphics, including decals, sponsor logos, and a special number. Have fun designing original racing graphics for your drawings. Make up wacky logos, create a cool paint job, and add your lucky number. You're limited only by your imagination!

You can copy these numbers or make up a style of your own.

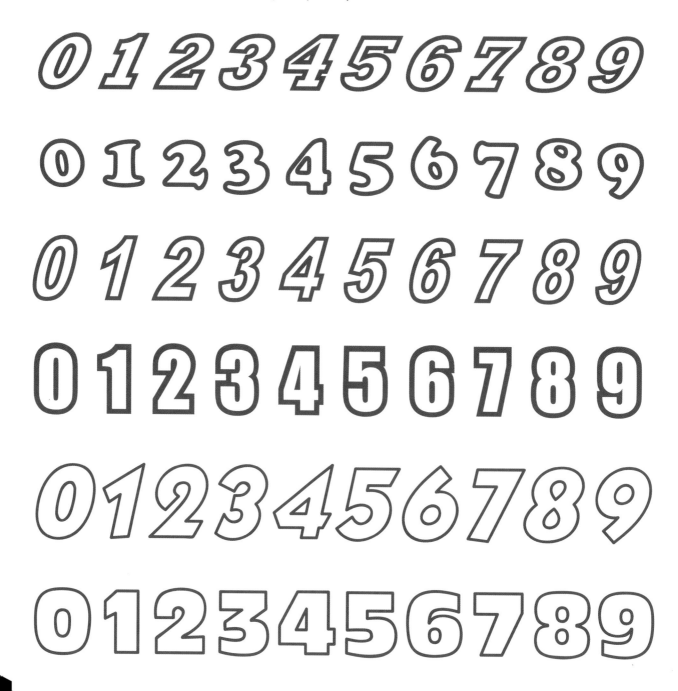

Here are some cool decals for your race cars. Draw some of these, and then try designing a few of your own.

① Start by drawing stars in various sizes.

② Next erase the center lines, leaving only the outlines.

③ Now you're ready to add color! Use bright colors to make the stars shine!

① Start by drawing the top of the cloud. Then add guidelines for the lightning bolt.

② Finish drawing the cloud and lightning bolt by following the blue lines.

③ It's time to color your drawing!

① Draw the outline of the shark. Don't forget its eye!

② Next add the mouth, teeth, fins, and gills.

③ Now color your shark with crayons, markers, or colored pencils.

① Use basic shapes to draw the bee's body, head, and wings.

② Add its stripes, stinger, eye, and frowning mouth.

③ Once you're happy with your drawing, add some color!

# Race Car Side View

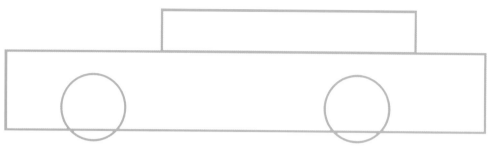

**Drawing Tip:**
It's always a good idea to start your drawing using simple shapes. Here, the rectangles and circles create the basic outline of the car.

**1** Use a ruler to draw a large rectangle. Then add small rectangle on top of it, as shown. The rectangles will help you see where to draw all the parts of the car. Next draw two circles for the tires.

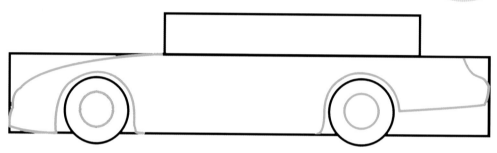

**2** Draw the outline of the car inside the large rectangle. Notice where the blue lines touch the rectangle. The front end is much lower than the back end. Add the wheel wells by drawing around the tires. Then draw a circle inside each tire for the wheels.

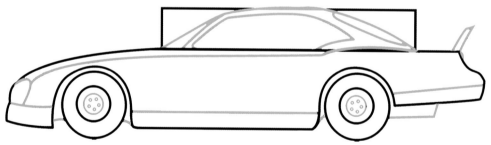

**3** Erase the large rectangle. Draw the top of the car inside the small rectangle by copying the blue lines. Then add the rear spoiler, the details on the wheels, the headlight decal, and the contour lines on the body of the car, as shown.

According to NASCAR regulations, a race car must weigh no more than 3,400 pounds (including the fluids) to leave room for the driver.

4 Erase the small rectangle. Then follow the blue lines to draw the rest of the details. Remember that NASCAR cars have a window net on the driver's side.

5 Now refine your lines and clean up your drawing by erasing any lines you don't need. When you're happy with your drawing, you might want to go over the pencil lines with a fine-tip black marker.

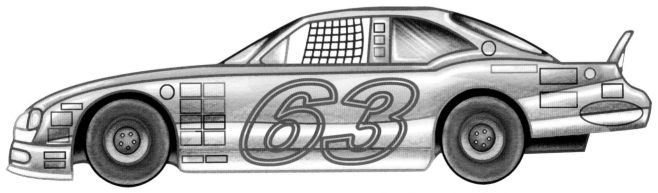

6 Now color your drawing with crayons, colored pencils, or markers. Get creative and design your own graphics and decals. Don't forget to add your favorite number on the side!

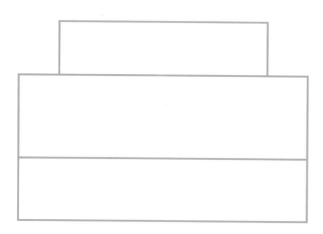

**1**

To draw the front view of a car, start by lightly drawing two large rectangles and one small rectangle, as shown. The rectangles will help you see where to place the outline of the car.

## Drawing Tip:
Once you've drawn the basic rectangles, use the corners as visual references for placing the body of the car.

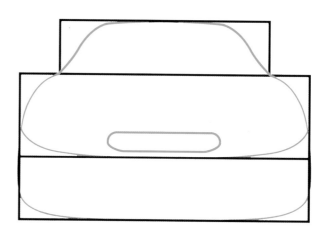

**2**

Draw the roof in the small rectangle. Then carefully draw the outline of the rest of the car in the two large rectangles. Notice where the blue lines touch the sides of the rectangles. Try to match the example. Then add a long oval for the grille, and erase the rectangles.

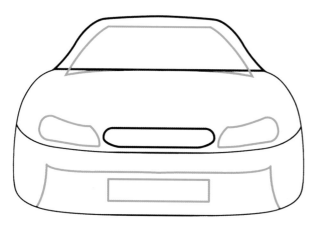

**3**

Add the windshield and the headlight decals. Then draw the line on the bumper cover, as shown. Don't worry if you make a mistake. Just erase it and try again!

A NASCAR pit crew has seven members: front tire changer, front tire carrier, rear tire changer, rear tire carrier, jack man, gas man, and gas catch man.

**4**

Draw the air dam and the steering wheel. Then copy the blue lines to add all the other details.

**Drawing Tip:**
Vary the weight of your pencil lines to match whatever you're drawing. For example, make a thick line for the grille's outline, but use thin lines for its details.

**5**

Refine the pencil lines you want to keep, and erase any stray marks.

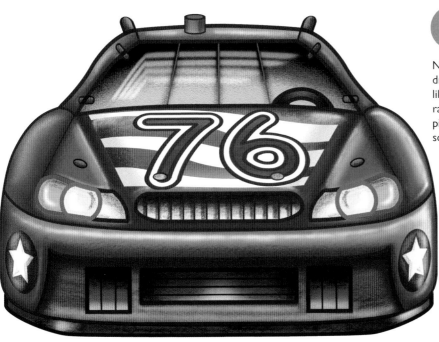

**6**

Now color your drawing any way you'd like. Create some racing graphics, add pinstriping, or design some sponsor decals.

For the rear view, begin with two horizontal rectangles, one large and one small. Then add two small vertical rectangles, as shown. When you draw the parts of the car, pay attention to where the lines touch the sides of these rectangles.

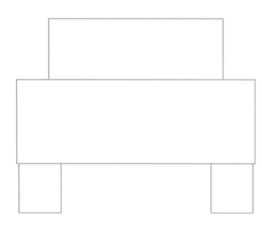

**Drawing Tip:** Start out making light pencil lines so they'll be easy to erase if you make a mistake. Once you're happy with your drawing, darken the lines with your pencil or a fine-tip marker.

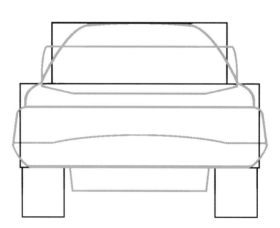

Now follow the blue lines to draw the outline of the car. First draw the roof and the back end, including the fuel cell. Then add the rear spoiler. Notice that the bumper extends outside of the large rectangle.

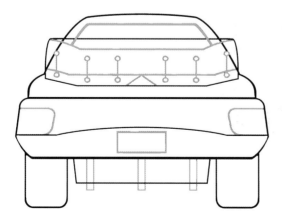

Round off the corners of the tires and refine the outline of the rear spoiler. Then erase the guidelines. Add the rear window and the six supports on the spoiler. Then draw the taillight decals, the license plate, and the braces for the fuel cell underneath the car.

A yellow stripe across the bumper of a race car indicates a rookie driver.

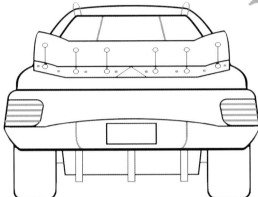

Copy the blue lines to draw the rest of the details.

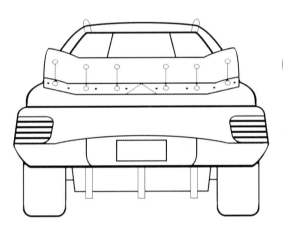

Once you're satisfied with your drawing, darken the lines you want to keep. If you wish, trace over the lines with a fine-tip marker.

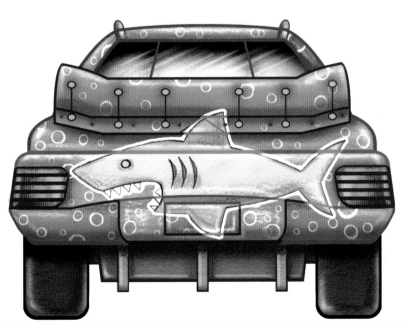

Now color your drawing with crayons, markers, or colored pencils. Add some cool graphics to make your race car unique.

**1**

This angle is kind of tricky. Take your time and draw lightly so your pencil lines will be easy to erase. If you have trouble drawing the guidelines accurately, try tracing this first step. (There's nothing wrong with tracing—it helps train your eye and hand to work together, which will improve your drawing skills.)

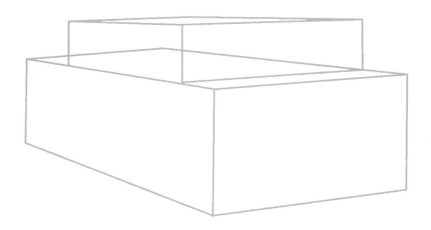

**2**

Draw the roof in the upper rectangle. Then draw the body of the car in the lower triangle. Follow the blue lines, trying to make your lines touch the rectangle guidelines in the same places.

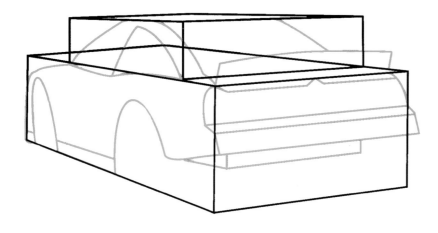

**Drawing Tip:**
Practice drawing rectangles in two-point perspective on a piece of scrap paper. Once you can draw a rectangle in proper perspective, drawing the car inside will be easy!

**3**

Now erase the rectangle guidelines and continue copying the blue lines to finish the basic shape of the car. Don't worry if you make a mistake. Just erase and try again. (Becoming a good artist takes a lot of practice!)

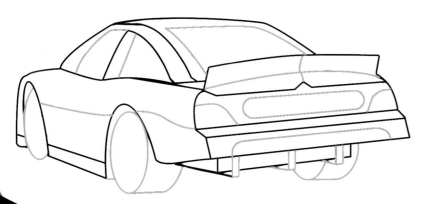

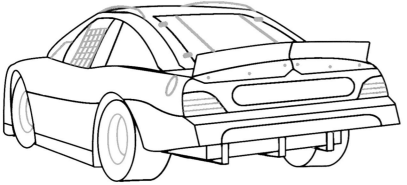

Use a ruler to draw the wheels, the window net, and the lines on the taillights. Then add the rest of the details, as shown.

**Drawing Tip:**
If you're just starting out drawing NASCAR race cars, you might want to begin with the side, front, or back view. The three-quarter views take some practice.

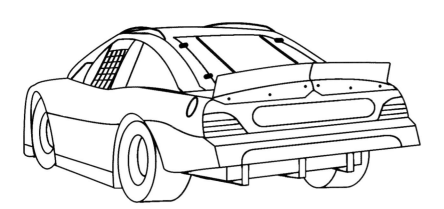

**5**

When you're happy with your drawing, darken the lines you want to keep and erase the rest.

Use your imagination to create some one-of-a-kind graphics for your race car.

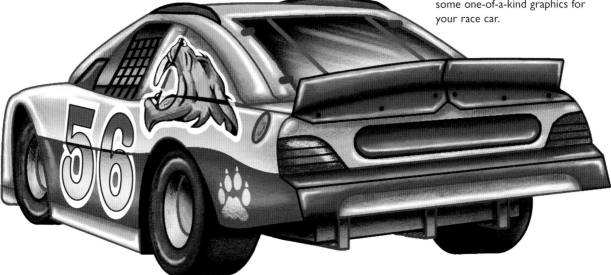

**1**

Drawing a race car from this view can be challenging. Go slowly and make light pencil lines so they'll be easy to erase. If you have trouble accurately drawing the guidelines, try tracing this first step. (Your drawing will be only as good as your guidelines.)

**Drawing Tip:**
As you draw, make the part of the subject that is closer to you appear larger than the parts that are farther away. This is called "foreshortening."

**2**

Draw the outline of the car within the guidelines. Follow the blue lines, taking time to make sure your lines touch the rectangle guidelines in the proper places. If something doesn't look quite right, erase it and try again.

**3**

Erase the guidelines. Then draw the hood, grille, headlight decals, air dam, tires, rear spoiler, and other details. Just copy the blue lines.

## 4

Draw the steering wheel, wheels, and window net. Then add all the details shown in blue. The small object on the roof near the center of the windshield is a camera!

## 5

Refine the lines as necessary. Then erase any stray marks and you're ready for color!

**Drawing Tip:**
To draw well, you need to learn to draw what you really see, not what you think you see! This is especially important when drawing a foreshortened view!

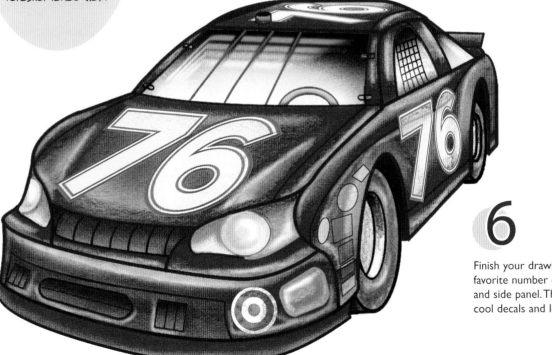

## 6

Finish your drawing by adding your favorite number on the roof, hood, and side panel. Then design some cool decals and logos.

**1** This view isn't as difficult as it may seem. Just use a ruler to draw the guidelines you see.

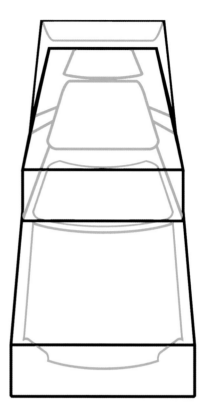

**2** Draw the outlines for the rear spoiler, rear window, roof, B-posts, windshield, and hood within the frames as shown in blue.

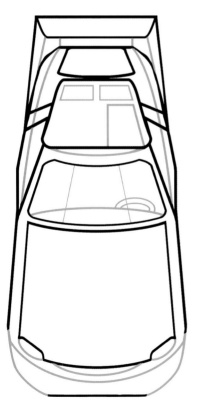

**3** Add the front bumper cover, the headlight decals, the dash, and the steering wheel. Working your way up, draw the details on the sides, roof, and decklid. When you've drawn all the blue lines, erase the guidelines.

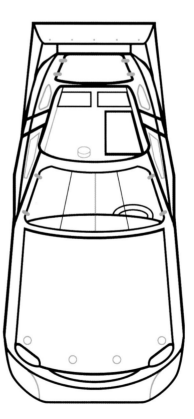

**4** Copy the blue lines to add all the details.

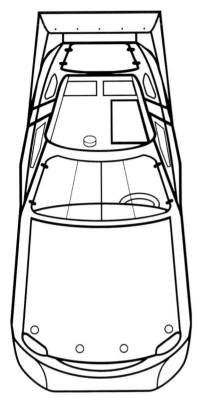

 **5**

Darken the lines you want to keep and erase the rest. Then get ready to color!

 There are 43 cars entered in each **NASCAR** race.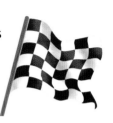

 **6**

Color your race car any way you'd like. This angle leaves a lot of space for logos, decals, and other graphics on the hood. Get creative and try something new!

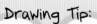
**Drawing Tip:**
It's important to practice drawing race cars from all angles. The more familiar you become with your subject, the better your drawings will be!

Use a ruler and light pencil to draw the guidelines for this top rear view. Just copy the blue lines.

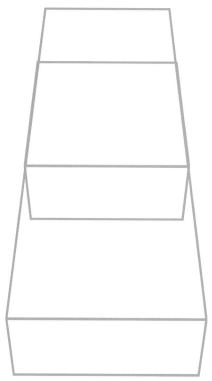

Draw the rear bumper and decklid. Next add the roof and windows, including the B- and C-posts. Then place the windshield and hood. Notice where the lines touch the guidelines. Make sure your lines match the example.

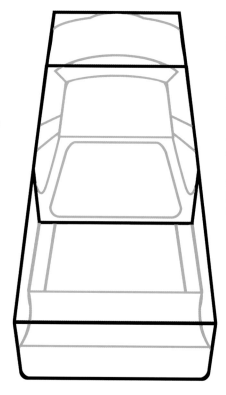

Erase the guidelines. Then draw the sides of the car, as shown. Next follow the blue lines to add the roll cage, rear spoiler, taillight, and other details. Don't worry if you make a mistake—just erase and try again!

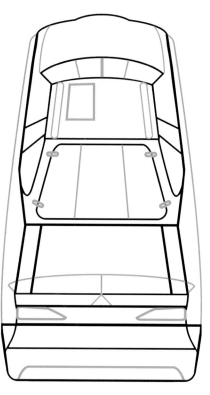

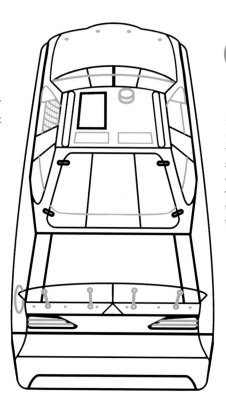

Place the details on the roof and rear end, as shown. Place a window net in the driver's side window, and add additional roll cage details inside all of the windows by following the blue lines. Then add the hood pins.

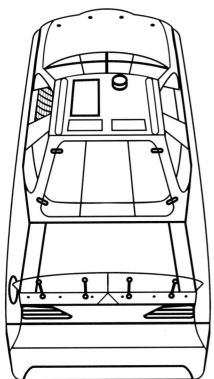

The temperature inside a NASCAR race car can reach 140 degrees! It gets so hot that a driver can lose from 5 to 10 pounds during a race!

**5**

Erase any stray marks or remaining guidelines and darken the lines you want to keep.

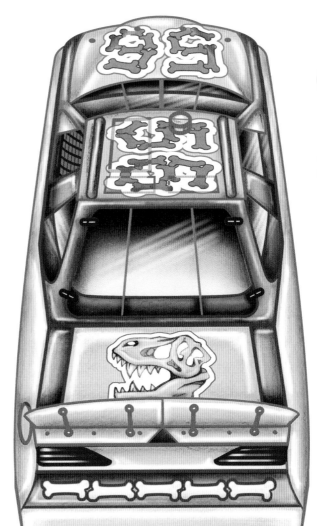

**6**

Now color your race car. Use your imagination to design some unique graphics and decals.

**Drawing Tip:** Erase the guidelines when you no longer need them or whenever they interfere with your new outlines.

**1**

To draw the NASCAR Craftsman truck, start by drawing a rectangle in perspective, as shown. (This will be the body of the truck.) Then add the guidelines for the cab of the truck.

**2**

Draw the front end of the truck. Notice where the lines touch the box. Add curved lines for the wheel wells, and draw the rear spoiler, windshield, and side window. Then add a line for the roll cage.

**Drawing Tip:**
If you have trouble getting the angle of this project just right, trace the first step or two. Then add the details on your own.

**3**

Add the hood, headlight decals, air dam, and grille. Draw two ovals for each tire. Add lines for the roll cage behind the windshield, and draw details on the rear spoiler, as shown.

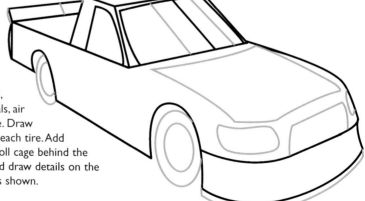

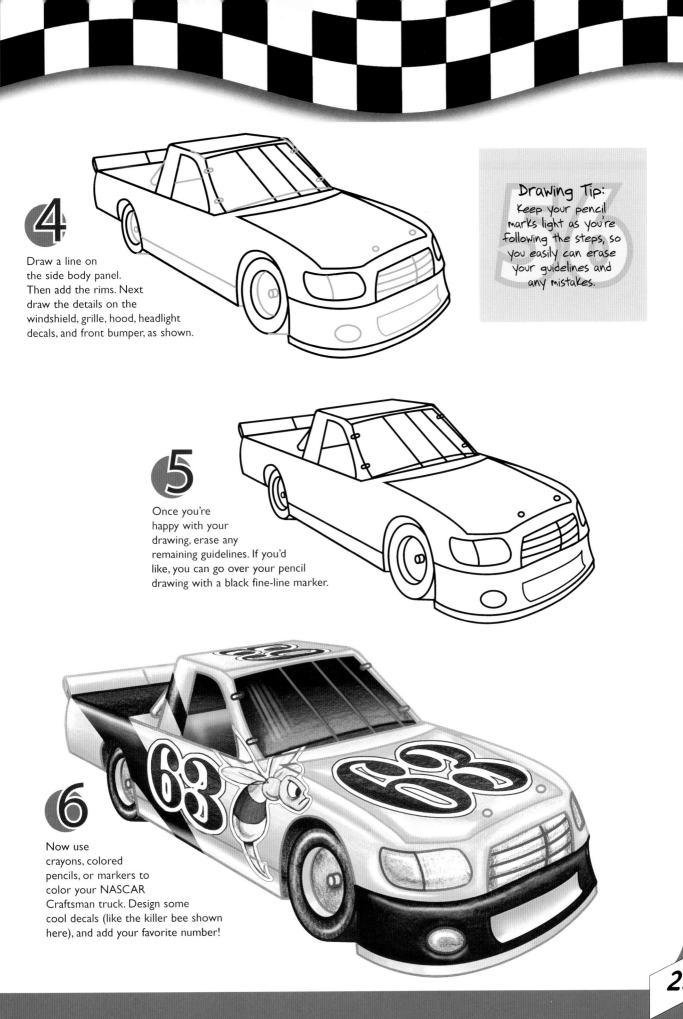

**4**

Draw a line on the side body panel. Then add the rims. Next draw the details on the windshield, grille, hood, headlight decals, and front bumper, as shown.

**5**

Once you're happy with your drawing, erase any remaining guidelines. If you'd like, you can go over your pencil drawing with a black fine-line marker.

**6**

Now use crayons, colored pencils, or markers to color your NASCAR Craftsman truck. Design some cool decals (like the killer bee shown here), and add your favorite number!

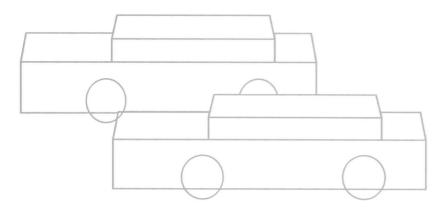

**1**

Use a ruler and light pencil to draw the rectangular guidelines as shown here. Then draw the four tires.

**2**

Draw the outlines of the cars within the rectangular guidelines. Copy the blue lines, paying careful attention to where the lines touch the guidelines. The add the wheels, side windows, and windshields.

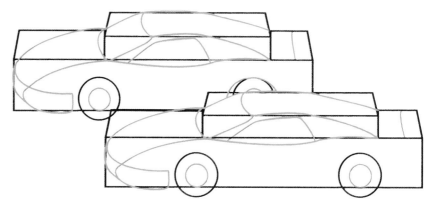

**3**

Keep adding details to the cars, following the blue lines. If you make a mistake, just erase and redraw. Once you're happy with the basic shapes of the race cars, you can erase the guidelines.

**4**

Draw a window net in each driver's side window, add small circles for the lug nuts on the wheels, and finish the details shown in blue. Then draw horizontal lines to indicate the lanes of the race track.

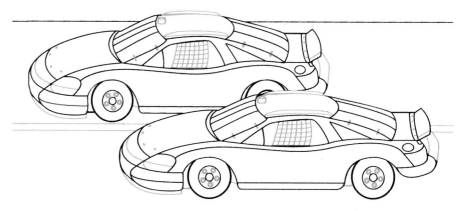

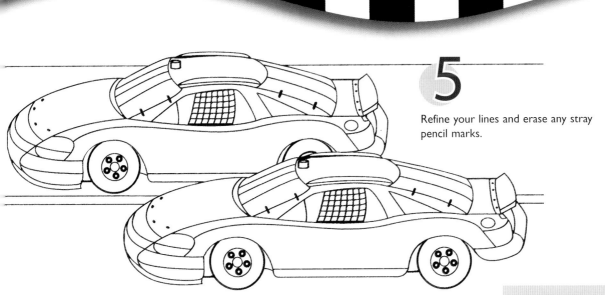

**5**

Refine your lines and erase any stray pencil marks.

**6**

Color the race cars, designing special graphics and decals for them. Be creative!

**Drawing Tip:**
When drawing two or more cars in the same scene, remember that the closer the car is to the viewer, the larger it will be—and vice versa. This little trick helps create the illusion of depth.

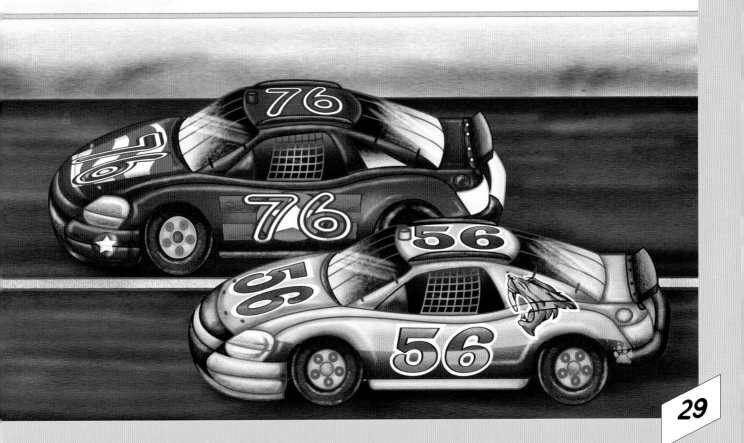

## 1

Begin with rectangular guidelines so you'll know where to draw the outlines. This drawing is very advanced, so you might want to trace the guidelines to make sure that you get a good start. Or you can practice drawing the cars individually before putting them all together.

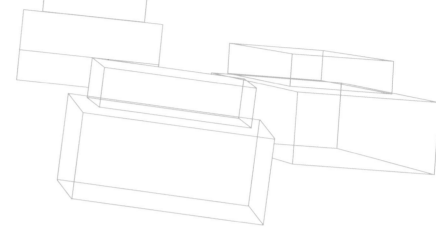

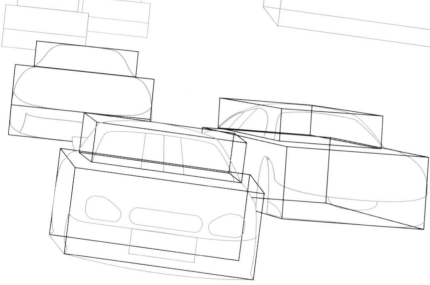

## 2

Next draw the outlines in the front three cars. Then add guidelines for the two cars in the background. Take your time and follow the blue lines, paying attention to where the lines touch the guidelines. Remember that cars closer to you will be larger than cars farther away.

## 3

Drawing one car at a time, copy the blue lines. Erase any guidelines you don't need as you go so they don't interfere with the details. Draw lightly so you can erase and adjust your lines as necessary.

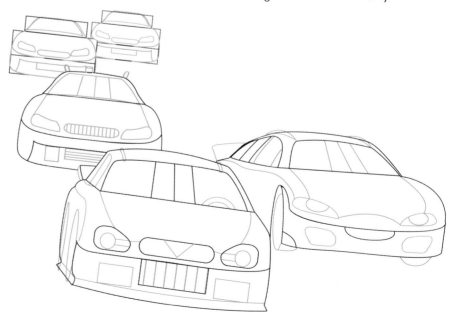

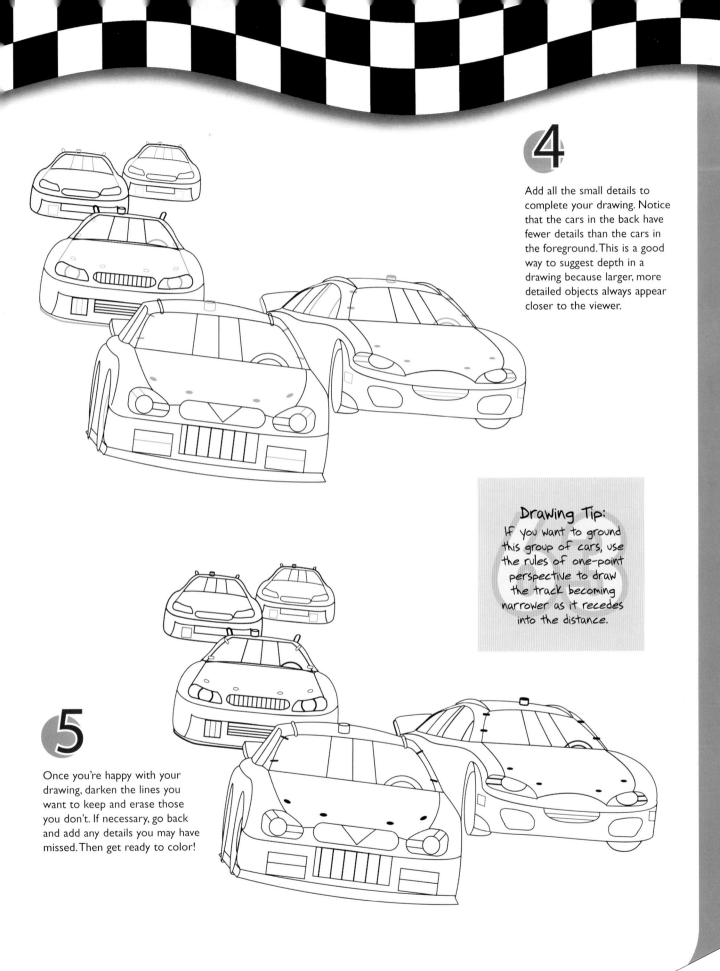

# 4

Add all the small details to complete your drawing. Notice that the cars in the back have fewer details than the cars in the foreground. This is a good way to suggest depth in a drawing because larger, more detailed objects always appear closer to the viewer.

**Drawing Tip:**
If you want to ground this group of cars, use the rules of one-point perspective to draw the track becoming narrower as it recedes into the distance.

# 5

Once you're happy with your drawing, darken the lines you want to keep and erase those you don't. If necessary, go back and add any details you may have missed. Then get ready to color!

**6** Design different decals and use a variety of color combinations to make each car unique. Have fun thinking of cool logos and graphics for each one—and draw your favorite number on the lead car!

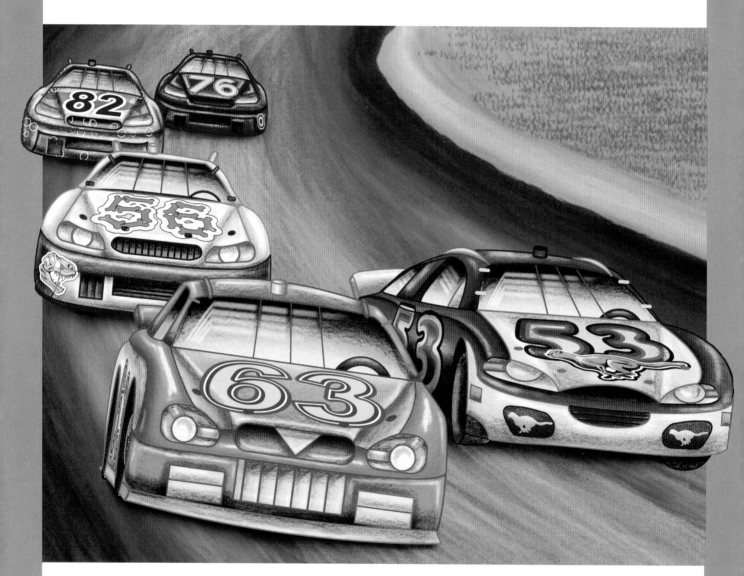

 NASCAR races were originally held on half- to one-mile oval tracks. With the creation of the "speedway," today the longest track is 2.66 miles long.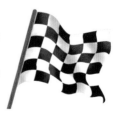